Science Fiction Novels Read

May 15, 2010 – March 15, 2014

John Wanzel

2014

in alphabetical order

The Hitchhiker's Guide to the Galaxy

Adams, Douglas

MaddAddam

Atwood, Margaret

Oryx and Crake

Atwood, Margaret

The Year of the Flood

Atwood, Margaret

The Windup Girl

Bacigalupi, Paolo

High-Rise

Ballard, J.G.

Kingdom Come: A Novel

Ballard, J.G.

Millennium People

Ballard, J.G.

Consider Phlebas

Banks, Iain M.

The Hydrogen Sonata

Banks, Iain M.

City of Bohane

Barry, Kevin

Leviathans of Jupiter

Bova, Ben

Ender's Game

Card, Orson Scott

The Yiddish Policemen's Union

Chabon, Michael

2001: A Space Odyssey

Clarke, Arthur C.

Catching Fire

Collins, Suzanne

Mockingjay

Collins, Suzanne

The Hunger Games

Collins, Suzanne

Abaddon's Gate

Corey, James S.A.

Caliban's War

Corey, James S.A.

Leviathan Wakes

Corey, James S.A.

Next

Crichton, Michael

The Andromeda Strain

Crichton, Michael

Dhalgren

Delany, Samuel R.

Do Androids Dream of Electric Sheep?

Dick, Philip K.

Ubik

Dick, Philip K.

VALIS

Dick, Philip K.

Down and Out in the Magic Kingdom

Doctorow, Cory

Eastern Standard Tribe

Doctorow, Cory

Makers

Doctorow, Cory

The Rapture of the Nerds: A tale of the singularity, posthumanity, and awkward social situations

Doctorow, Cory

A Fire in the Sun

Effinger, George Alec

The Exile Kiss

Effinger, George Alec

When Gravity Fails

Effinger, George Alec

A Visit from the Goon

Squad Egan, Jennifer

A Hologram for the King

Eggers, Dave

The Circle

Eggers, Dave

American Gods

Gaiman, Neil

Anansi Boys

Gaiman, Neil

All Tomorrow's Parties

Gibson, William

Count Zero

Gibson, William

Idoru

Gibson, William

Mona Lisa Overdrive

Gibson, William

Neuromancer

Gibson, William

Pattern Recognition

Gibson, William

Spook Country

Gibson, William

The Difference Engine

Gibson, William

Zero History

Gibson, William

Keyhole Factory: A Novel

Gillespie, William

The Forever War

Haldeman, Joe

Judas Unchained

Hamilton, Peter F.

Pandora's Star

Hamilton, Peter F.

Agelmaker

Harkaway, Nick

The Gone-Away World

Harkaway, Nick

172 Hours on the Moon

Harstad, Johan

The Possibility of an Island

Houellebecq, Michel

Never Let Me Go

Ishiguro, Kazuo

Gods Without Men

Kunzru, Hari

Transmission

Kunzru, Hari

Spinward Fringe Broadcast 0: Origins

Lalonde, Randolph

Spinward Fringe Broadcasts 1 and 2: Resurrection and Awakening

Lalonde, Randolph

The Dewey Decimal System

Larson, Nathan

Ancillary Justice

Leckie, Ann

Energized

Lerner, Edward M.

Girl in Landscape

Lethem, Jonathan

Gun, With Occasional Music

Lethem, Jonathan

The Flame Alphabet

Marcus, Ben

Embassytown

Miéville, China

Iron Council

Miéville, China

King Rat

Miéville, China

Kraken

Miéville, China

Perdido Street Station

Miéville, China

The City and the City

Miéville, China

The Scar

Miéville, China

Ghostwritten

Mitchell, David

number9dream

Mitchell, David

Equations of Life

Morden, Simon

Altered Carbon

Morgan, Richard K.

Broken Angels

Morgan, Richard K.

Woken Furies

Morgan, Richard K.

1Q84

Murakami, Haruki

The Age of the Conglomerates: A Novel of the Future

Nevins, Thomas

Ringworld

Niven, Larry

A Naked Singularity

Pava, Sergio De La

The Recollection

Powell, Gareth L.

The Long Earth

Pratchett, Terry

Boneshaker

Priest, Cherie

The Islanders

Priest, Christopher

Gravity's Rainbow

Pynchon, Thomas

The Quantum Thief

Rajaniemi, Hannu

2312

Robinson, Kim Stanley

Red Mars

Robinson, Kim Stanley

The Ware Tetralogy

Rucker, Rudy

Old Man's War

Scalzi, John

Luminarium

Shakar, Alex

Frankenstein

Shelley, Mary

Everything Is Broken

Shirley, John

Super Sad True Love Story

Shteyngart, Gary

Mr. Penumbra's 24-Hour Bookstore

Sloan, Robin

Interface

Stephenson, Neal

Reamde

Stephenson, Neal

Snow Crash

Stephenson, Neal

Roadside Picnic

Strugatsky, Arkady

Far North

Theroux, Marcel

Rainbows End

Vinge, Vernor

Slaughterhouse-Five

Vonnegut, Kurt

The Age of Miracles

Walker, Karen Thompson

Infinite Jest

Wallace, David Foster

The Broom of the System

Wallace, David Foster

Alif the Unseen

Wilson, G. Willow

Going Clear: Scientology, Hollywood, and the Prison of Belief

Wright, Lawrence

How to Live Safely in a Science Fictional Universe

Yu, Charles

www.ingramcontent.com/pod-product-compliance
Lightning Source LLC
Chambersburg PA
CBHW022022170526
45157CB00003B/1313